The universe is vast and impossible to fully comprehend. The complexity reveals a fundamental observation:

We are creatures experiencing our lives in a diverse and beautiful place.

This book collects and examines multiple perspectives of personal identity, expressed as individual pieces of words and art.

Dedicated to my family with love.

Brett Engle

Beside Myself, Words + Art
Copyright © 2013 by Brett Engle
All rights reserved
ISBN-13: 978-1-4818-9487-6

Published in the United States of America
First print edition 2013

Book design, illustration, and writing by Brett Engle

No part of this book may be reproduced or resold in any form by any means without permission first obtained from the author. This includes reprinting, excerpts, photocopy, screen capture, recording, or any future means of reproduction.

Permission must be obtained first before copying anything in this book. Contact the author at http://SpiritualAnimal.com

When I am old
may I become wilder,
more free
than my youth would dare to be.

To love ever louder,
in peace be surrounded,
when I am older
and feeling bolder.

There may happen
a disaster,
remind me to use laughter,
when I am old.

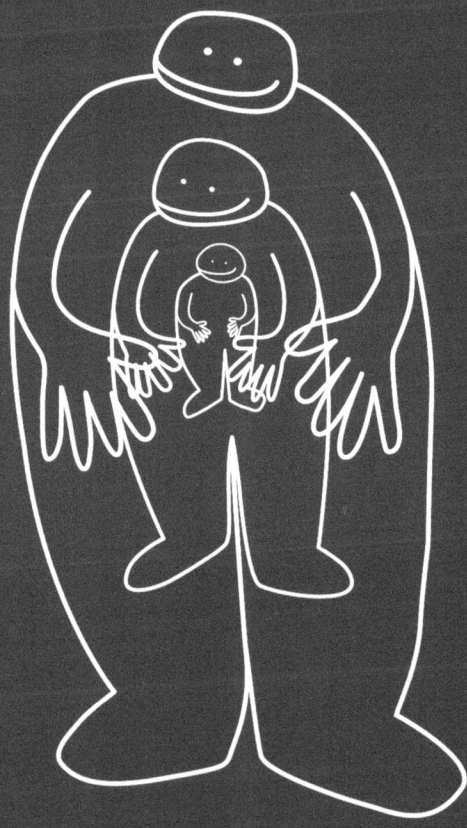

Pocket full
Want clouds, sky
I feel the shadows shift
I drift with
small nuances in this
pull me back,
I scope
I search

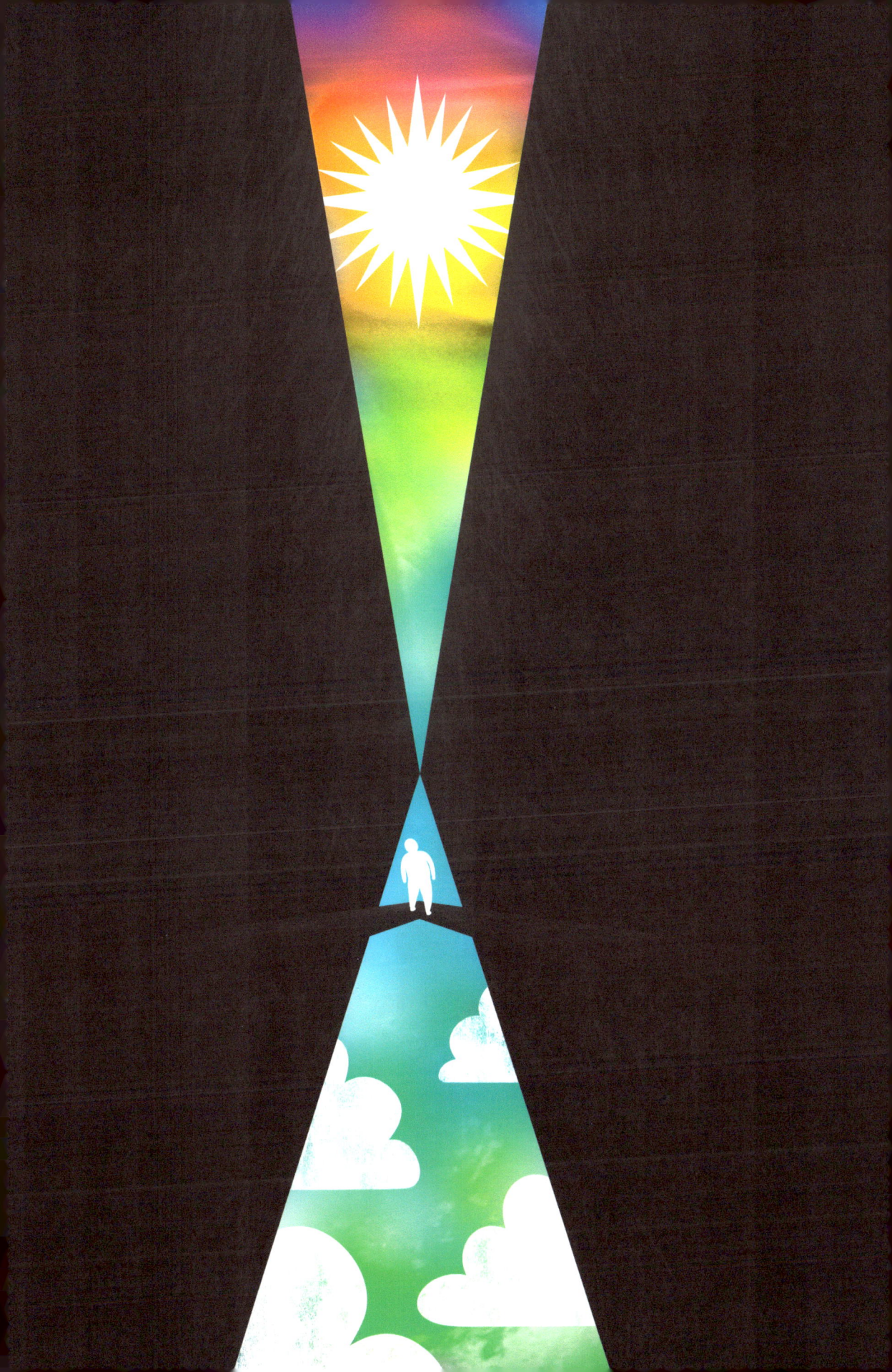

Across this country and world
there is a long string of
cords and chatter,
boxes, poles.

And me,
riding in a Cadillac
on any pleasant day,
when my grandma
could still drive...
I knew.

Watching those lines
telephone play
shadows bouncing on the blacktop
as we drove legally,
careful to things,
cautious...

I felt beautiful;
I brought the sun behind me.
But now I transport her,
watch her grow
in a backwards way

and a small-sad cry escapes me.

Favorite hour
rolling in and no one
not even me
notices
a fog a bird asleep
Eleven
like morning for the night
rising moon light
the time
an hour late
nothing to do
and my god it's Friday
I'm the only one singing
scribbling
making these
little faces
at myself in the mirror

Lake beside the highway
Time to spend thinking
Left my imprint in the grass
I arrive again and again
2:15 6:10 9:15 AM PM
Dry wet white black
Just starting out
Last leg of miles to home

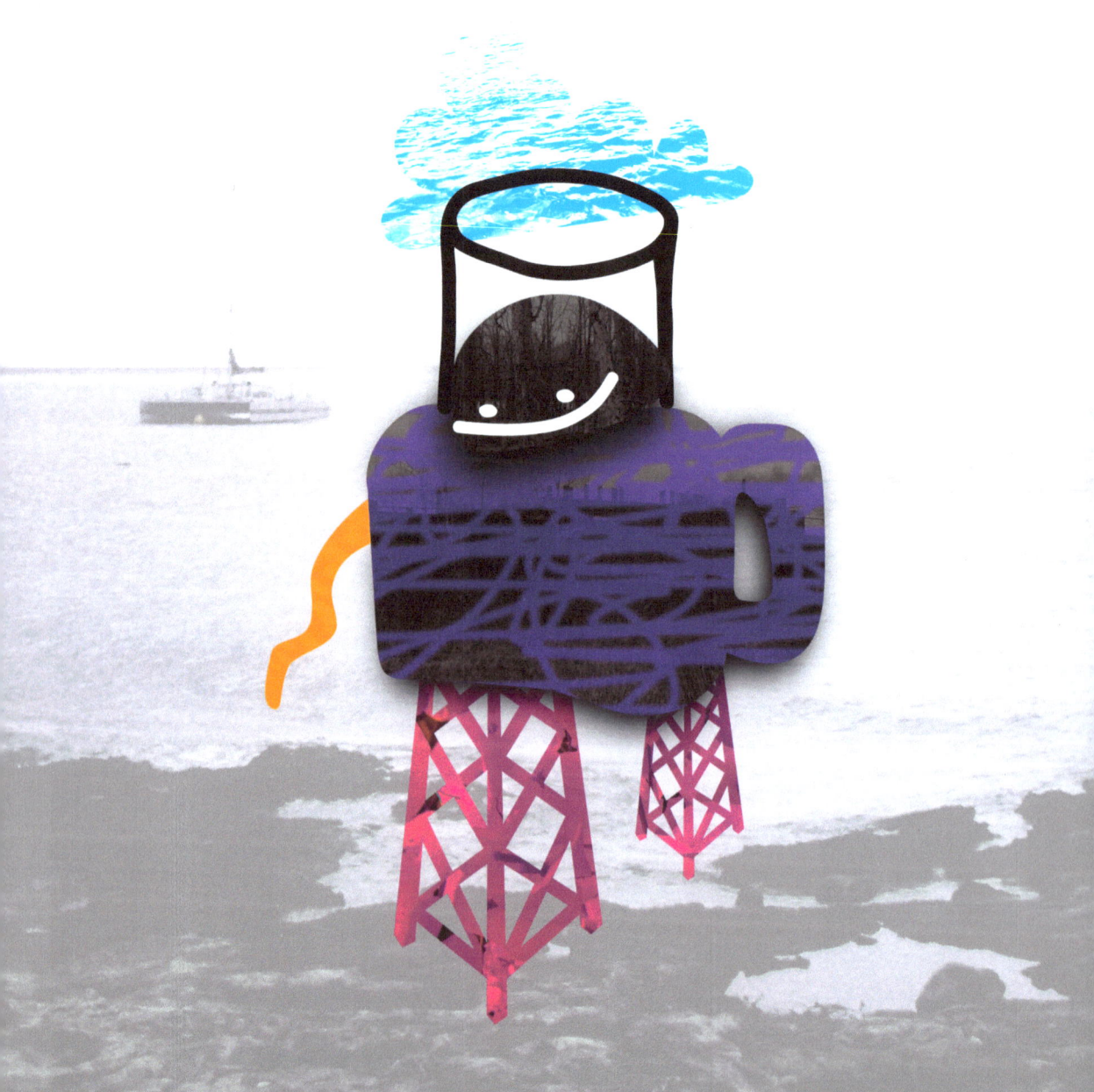

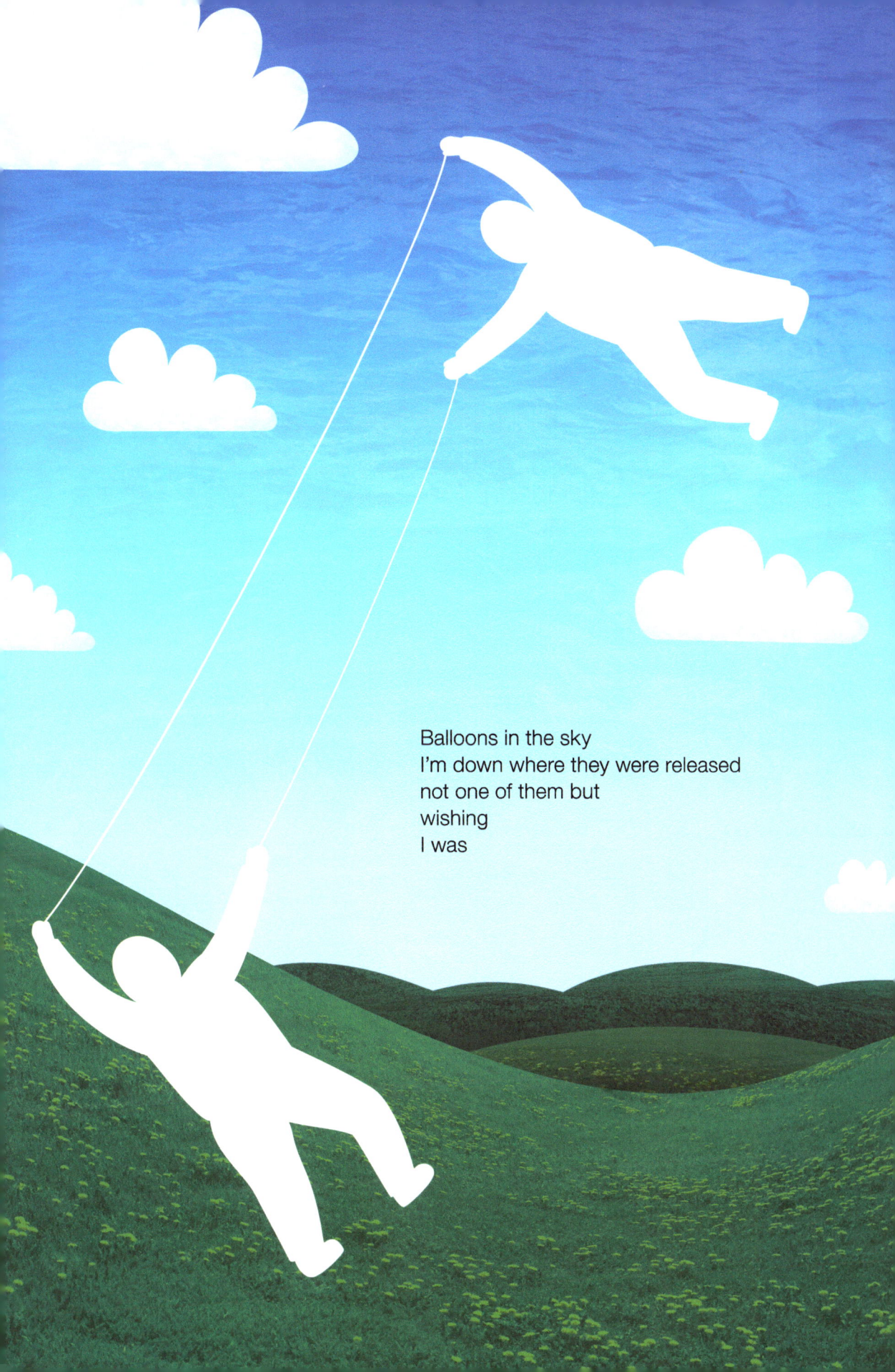

Elderly man
Skitter between the two white lines
Race the blink-blink of more
Hands in front of you

Midwest
people rhyme
outside
they don't speak they
have sayings they survey
and tiss toss
ideas about to each
I laugh you laugh
I avert my eyes you charge forward
at nothing at me just
simple me
at your reflection in
this skyway
window.

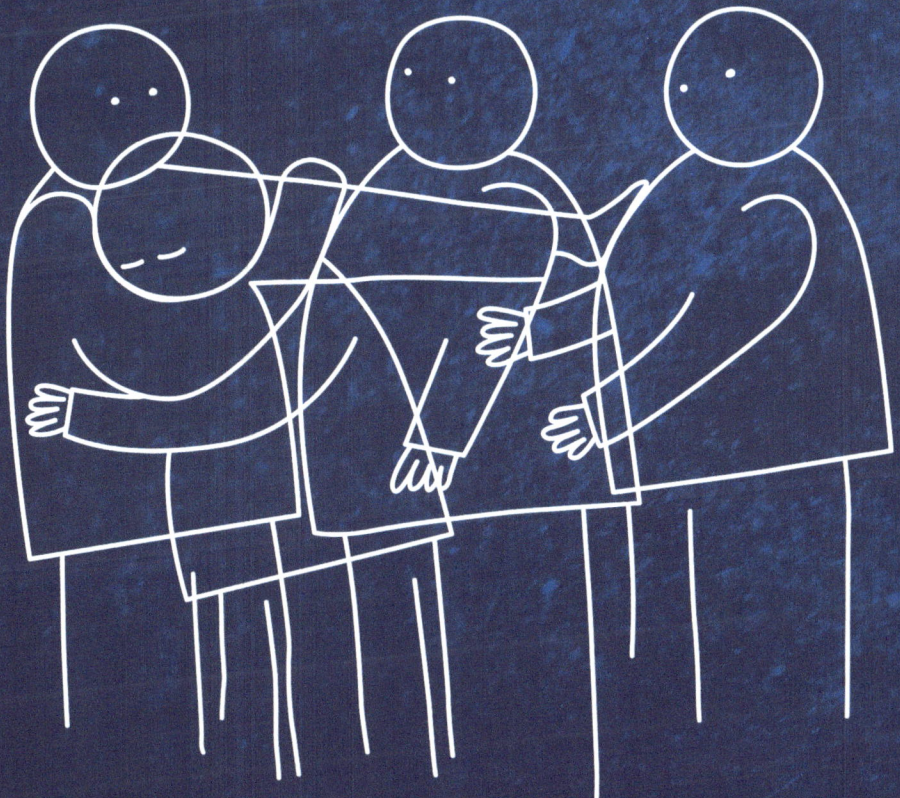

Don't get up, but
I
am
just below your windows*
outside
while you sleep.

In total safety,
I gaze up,
horizon stretching purple to blue.

Never so near
yet here feeling rumbling slumber

Standing this watch
next to your lot
barefoot in the grass
spell being cast.

*your
windows pour dreams (boats)
drapery launching,
see them go
windy transparent love
gusting
into the night.

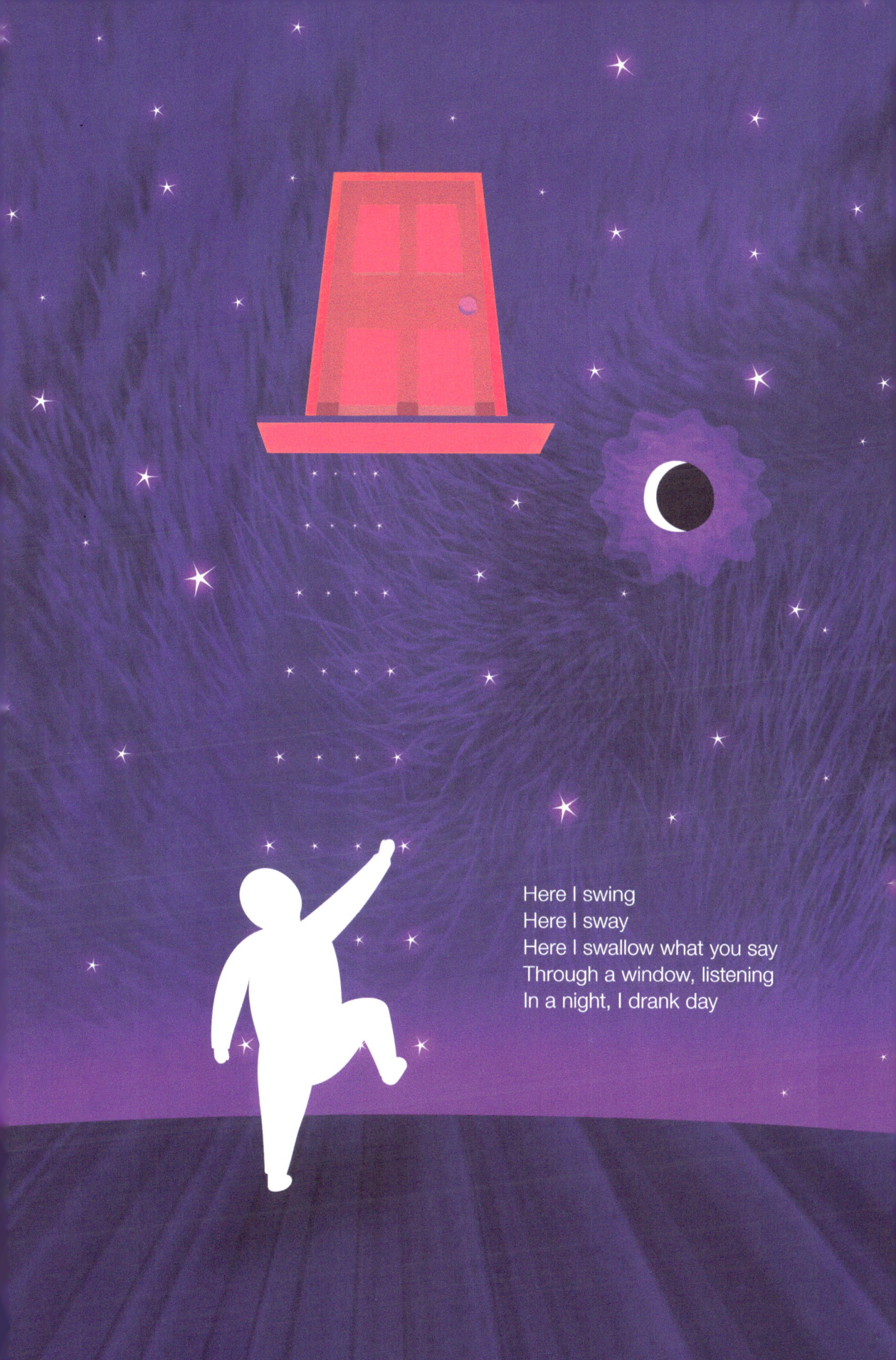

I think my legs are smarter than me.
They know that from some angles they are beautiful,
They dance and in certain light glow.

Tonight at this campfire I swat at them,
wishing for light breeze.
Stretching back, I cross my legs and lay down,
gazing upside down at the cold moon.

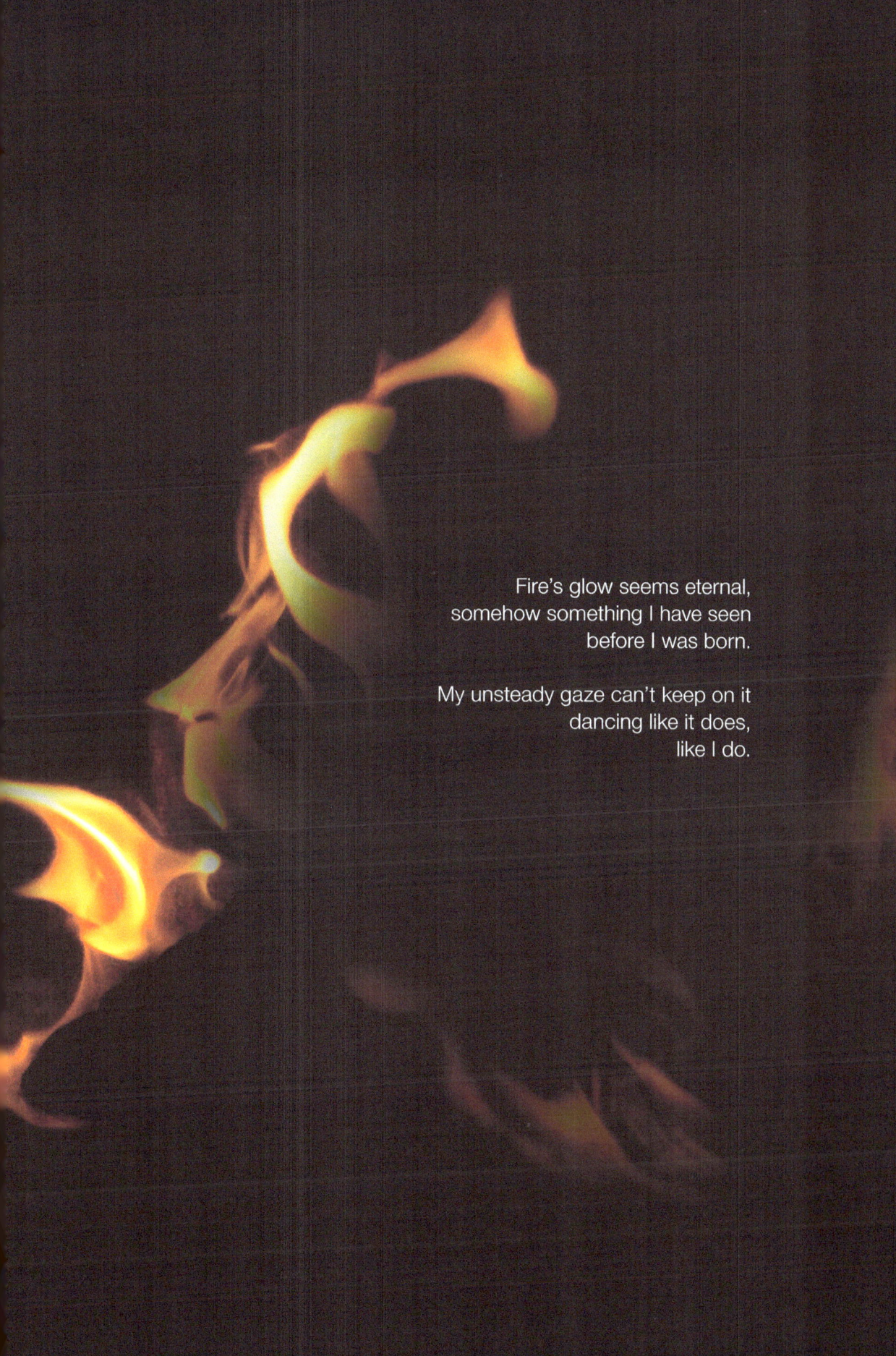

It was not a night
Nice sight
Imagine, us apart.
From the billboards of you in my mind
sprung beautiful flowers and trees.
But
the structure of your face
became more important
than the structure of your heart.
Better and better and better
Hastily glued
My colors new
No longer two

Talking about my body like it's not here
isn't near and can't hear

Singing to my mind
skies clear

Teaching my hand to be new
one better than two

One light out
another on
porch lights from across the road flicker
a case of indecisive illumination
observing all night the suburban damage,
a big city problem,
my rural affection.
One down
but the brighter lights will never go off
I may be on the ground
still looking ahead
(Just
documenting the dark)
"No worries now, beautiful."
I said.

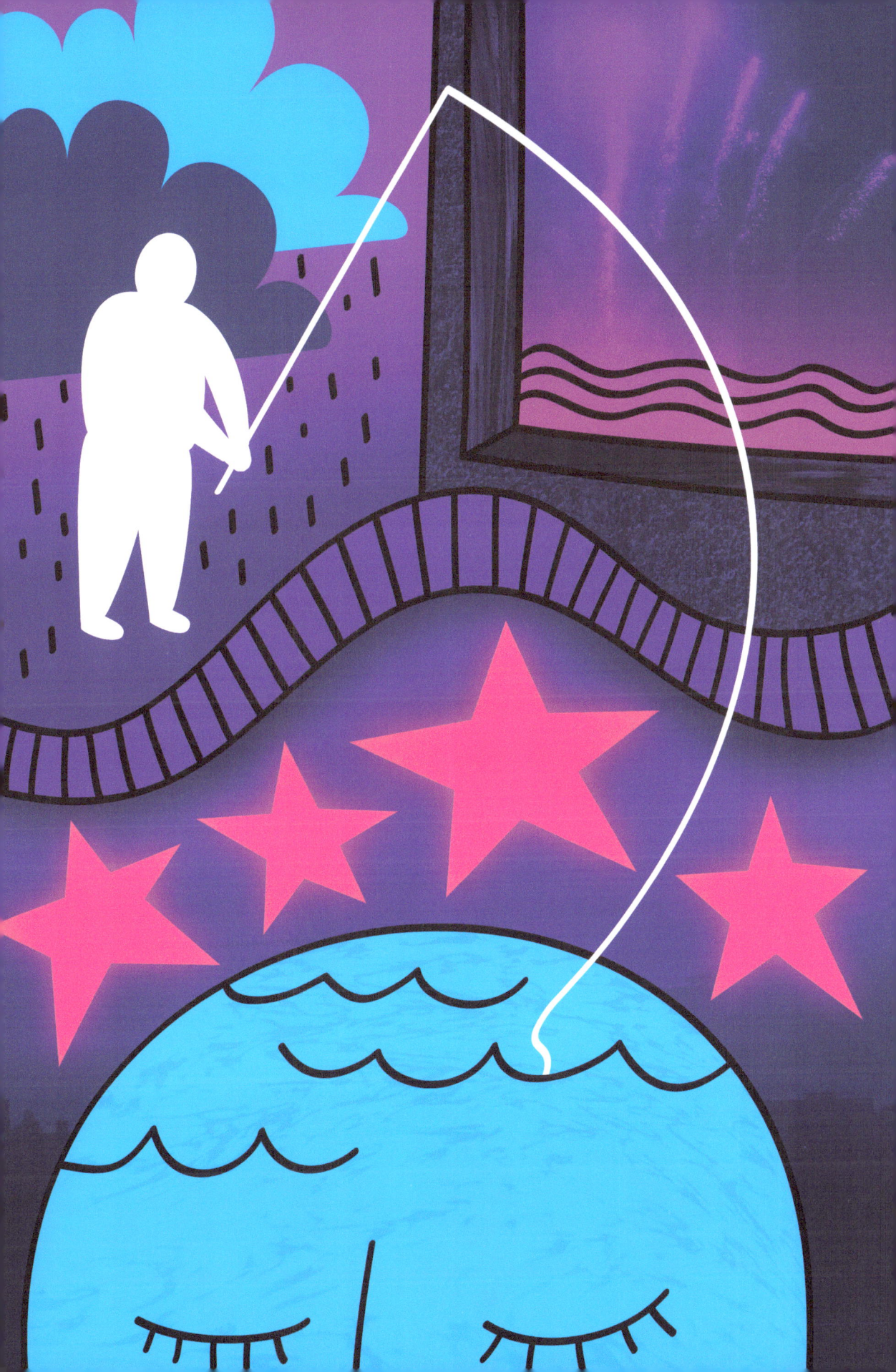

Forgive this vision,
long at times,
obsessively impressed by inspiration,
I see forward
from here
a calm clarity builds us to be braver.
Might the process shatter
my broken pieces
again, smaller like sand
and
let them then scatter,
settle peacefully
inside the soft footprints
along beaches
of your kind heart.

Driving my car right through
a slice of gray February
I love that you always know what I want to see

No caution contraption
calls that need to happen
set before a million plates
of maybe
or maybe.

Here
 we go again
 into
 upward to happiness

sweet light
all around
complete
in sheets
birds
quiet: an airport
to us.

 So unwilling to breathe
 making quiet a
 runway
 planes coming going
 my heart

my love

 an airport
 fueling wings higher
 flight for me up
 I love you

for now
tell your attendants
take a break

Hop a train with me

You talk about the sea being only 1 mile away.
I spy the sea in your sunglasses,
your vision flooding my eyes.

I took off my costume when I took off my necklace
I found the water's edge when I found your car.

You still talk
about as long as these tracks back home,
about as open as these motorways.

Again around
This time the leaves stain the sidewalks & driveways
The cars seem to putt-er puffed in cloud surround
No snow yet
He has slight hesitation for the bus
Seasonal cyclical waiting
While birds in the bushes tell secrets
Things I didn't know
Odd facts I did

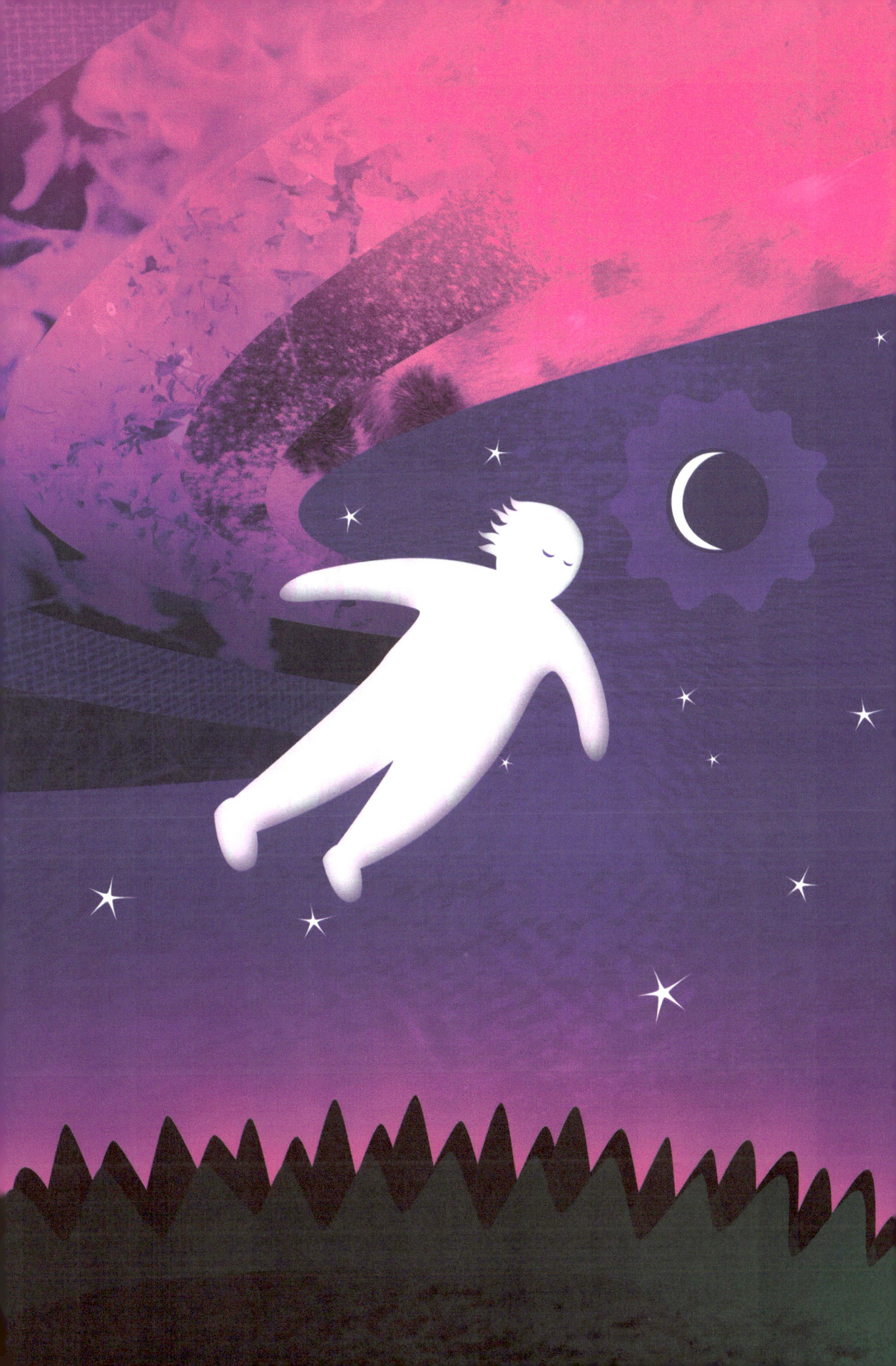

It isn't over until I say it's over
Over where?
Over in the place where
I saw you change your mind
and stretch your arms wide around the night
to perform serious peacefulness
Shaken in my final fist
like a needed gamble

Pounding snowflakes
write upon my windshield
gossiping about the
sincere becomings of winter.

Sort of like this American flag
I see everywhere
lately;
ribbons like leaves along the streets
of my mind's city.

And I'm about to spend my money
on a gamble to meet
my future self.
Come meet me;
watch,
while I step forward to become him.

You are not mine but you are my gentle
(in my arms, exiting my apartment,
hands that won't leave)
love.

I know
you wear your freedom like the clasp of a necklace
back there
and I see it as you go.

Days pass, you still aren't mine
yet
(your traffic patterns)
I say the roads know otherwise.

Paths from your place to mine,
are head to toe
Affection travels the short distance like blood
(two hearts)
that ultimately changed course.

There is so much I'll never know about you
(alternate routes)
We are free
in a world that is the perfect stranger.

Don't need an examiner eye to scan my fears;
unless it's mine,
and that one never blinks
 that one never blinks.

I don't do well while you're watching me,
so I'll cast a shadow for all to see
onto the clouds that hold this night
 we hold this night.

Beside myself, somewhat lost somewhat great.
Must be comfortable with my cage.
Earth-enamored. Star-eyed. Home inside.
I'm not your ghost, you're mine.

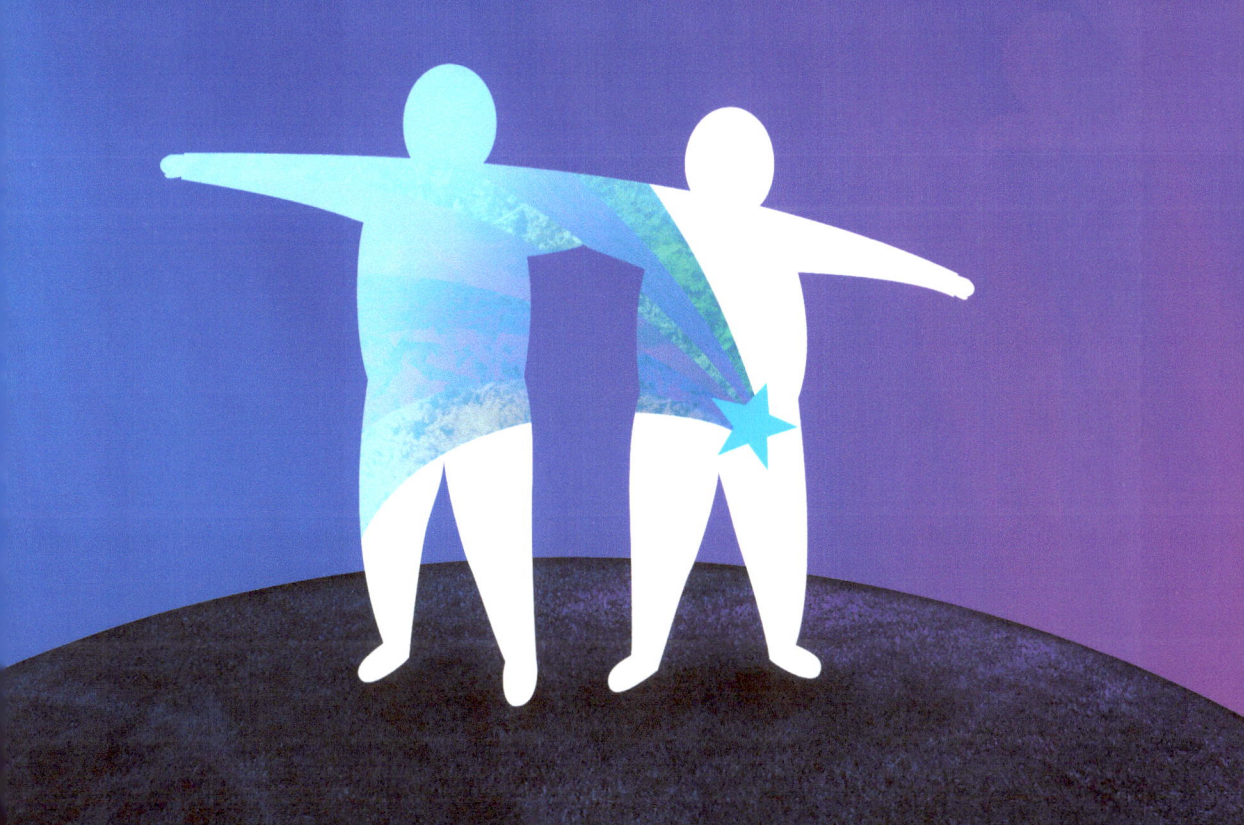

Oh I remember December:
 The pivot bridge of snow underfoot
 Small tingle breath of cold up your leg
 The quiet
 Closed-door twisting crunch of passing cars
 Walking and walking (maybe rabbits)

This is just as good a time as any:
 to focus deeply on love
 to warm our deepest, wintry heart of hearts
 to point North toward peace

It is not violator month. It is not cold corrupt.
It is December: bright quiet window open for the world.

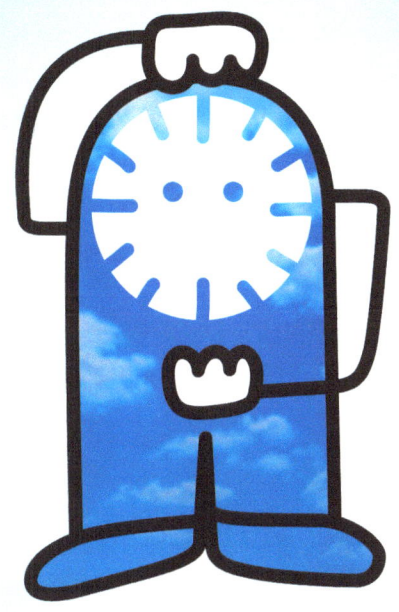

This travels this
shines for miles beyond my body
That sounds absurd, but see

This is what it does this
means more than here, where we are
This means more than me

I see this in us
and I don't fear it,
I love it
This is a gift
and we should let it travel

Cosmically wasteful
come to the table.

Used ten years to discard distances not far.

Shouldering a tension
too sick to mention;
please reboot connection.

Are we reversing, or beings lost?

Fear and judgement
will not help this.
Ugliness is unworthy of devotion.
Our cultural sense of wonder has walked
eight steps toward hell.

So, instead,
say true beauty is cool.
Watch for clues.
Peacefully walk beyond ignorant extremes.
Practice kindness.
Don't give up.

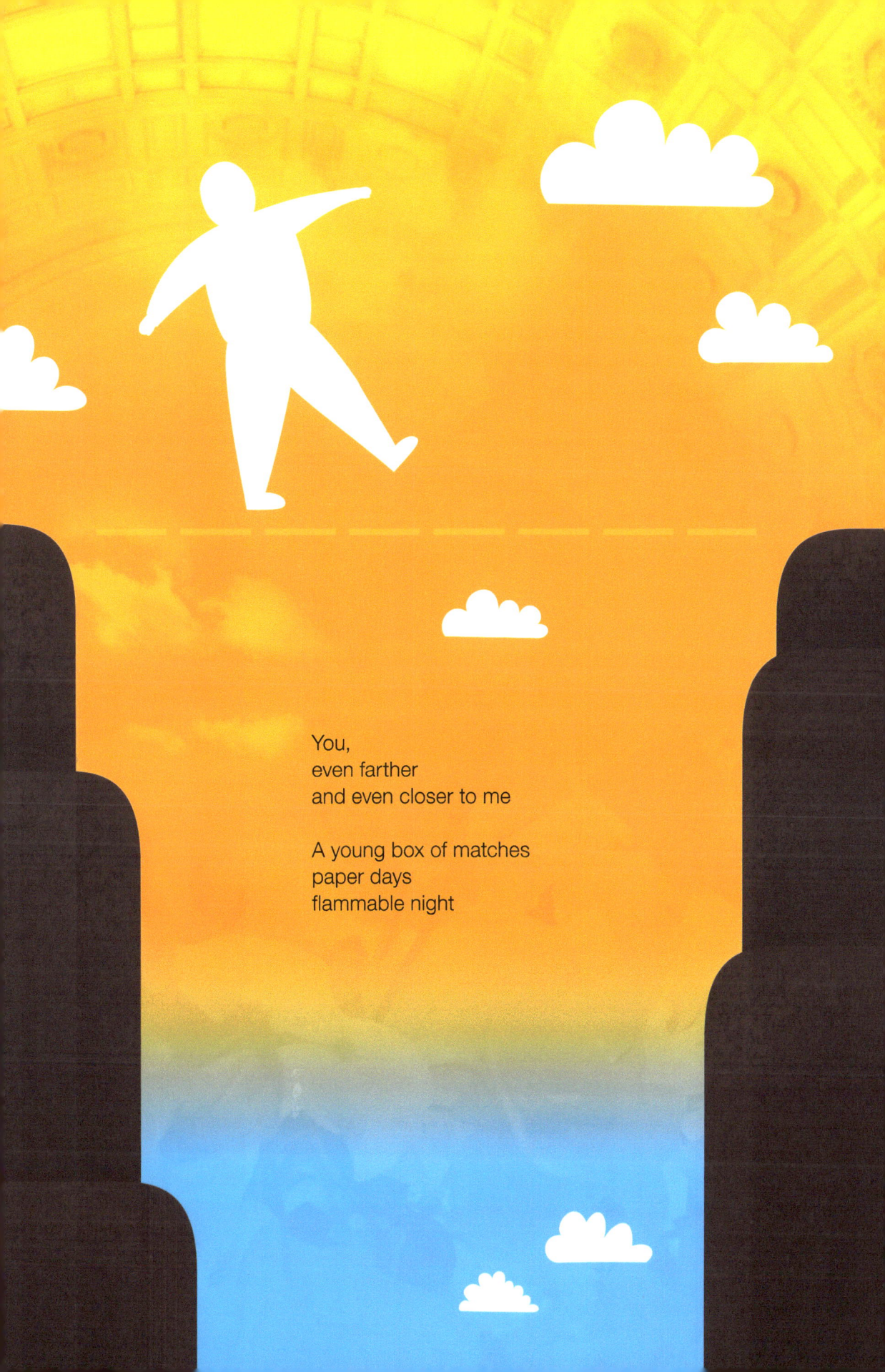

I've connected with many maybe
false walls
some times.

Each was true
only
in their own way.

Now & again
I've tripped into a flat moment,
a sequence of events all falling forward toward
confusion
contention
disconnection.

My metaphorical pastures
as green as any so why lay here?
Hug so concentrate my arms pucker
my thanks
my heart, unknown?

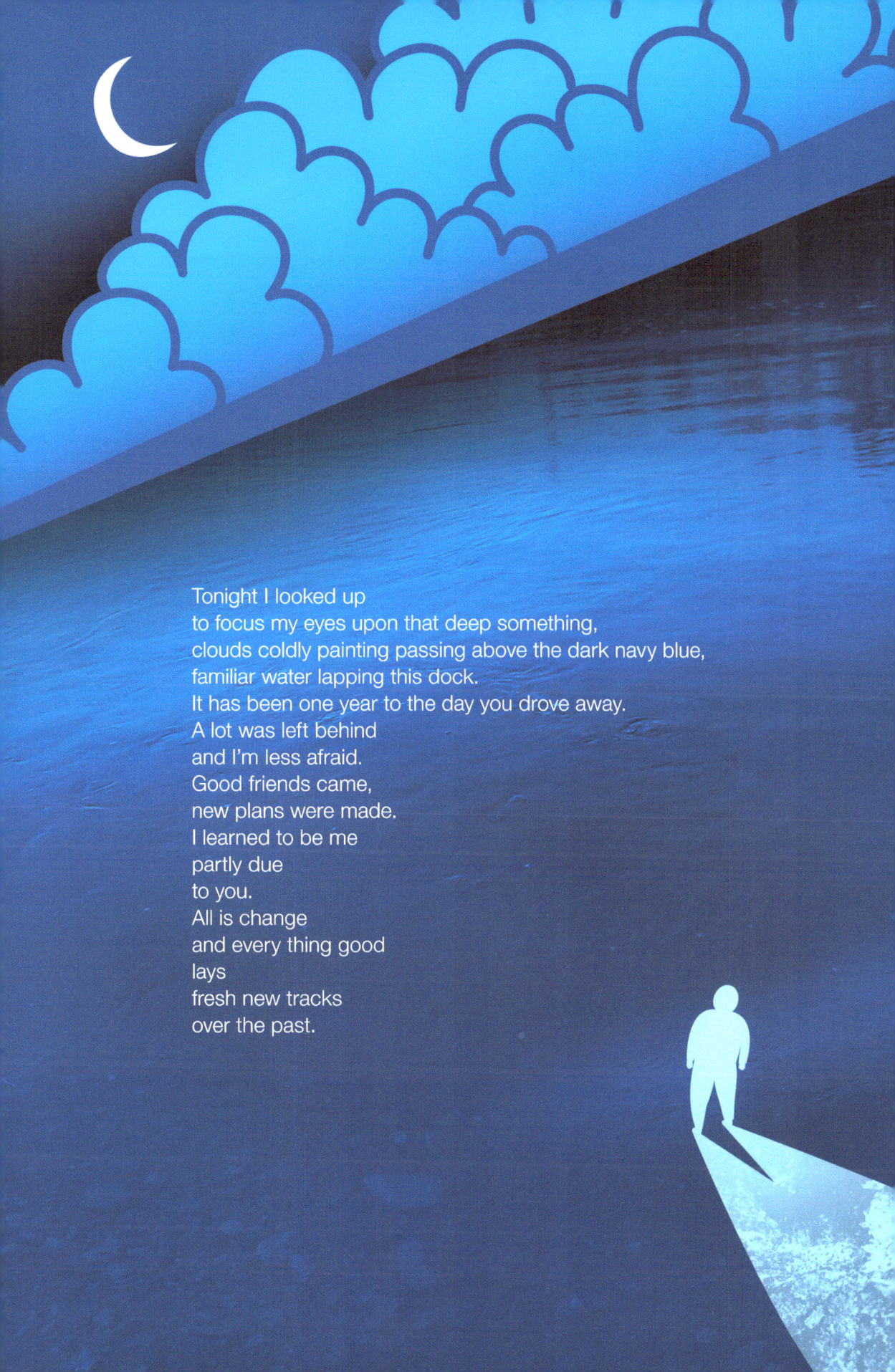

I am quiet right about now

Not necessarily at peace nor upset, but
my
sandy plains
got a little too close to my
oceans, and now humble

I am beaches, pieces,
centillion washing away
sand
carried out

obvious quiet

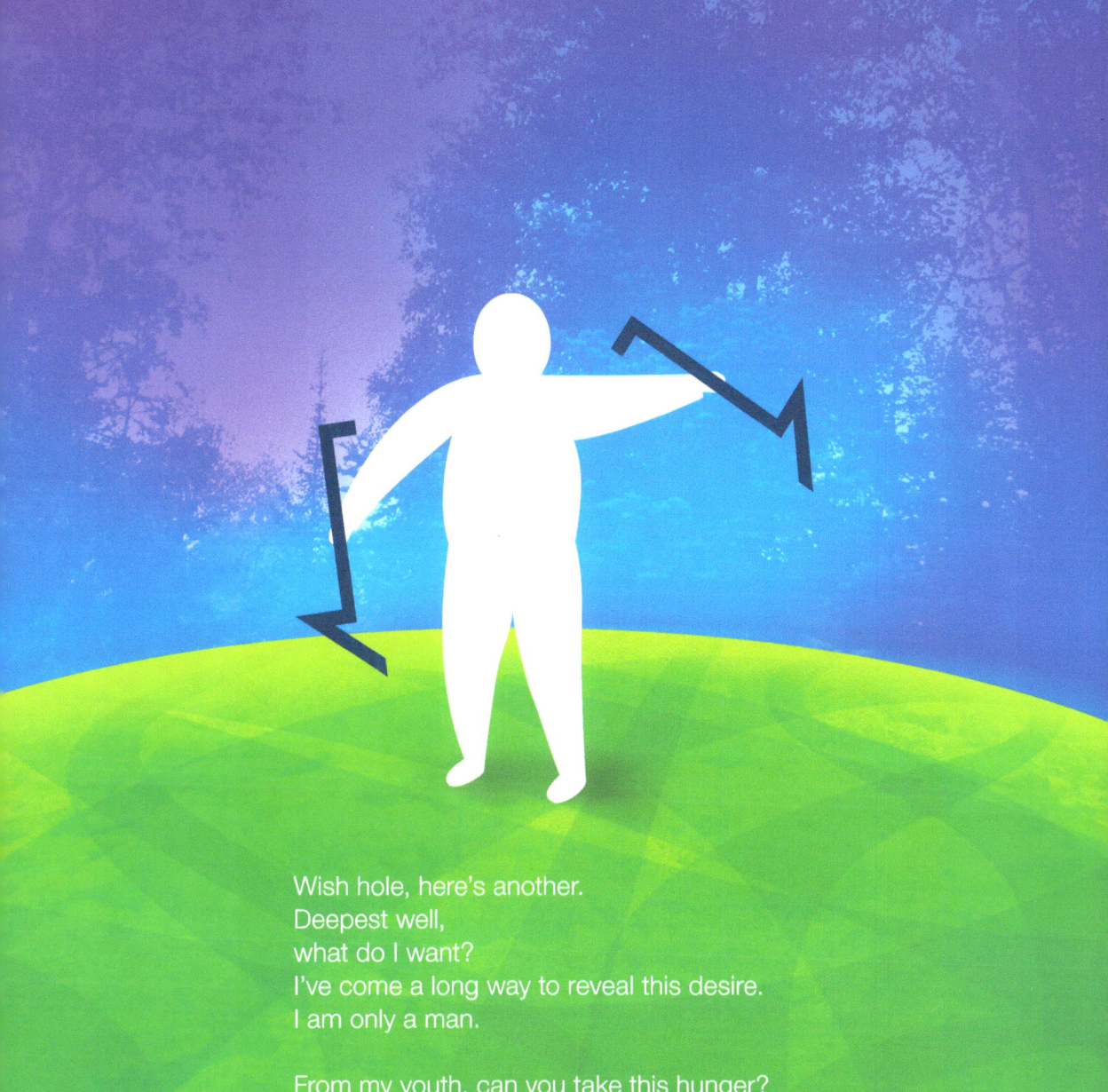

Wish hole, here's another.
Deepest well,
what do I want?
I've come a long way to reveal this desire.
I am only a man.

From my youth, can you take this hunger?
From one path
bend me anew
wiser, warmer, move me around.

I'll make a curse my blessing,
or a blessing
into wings.

I can't quantify
enough
(to please myself)
the lives of the people I meet
into words.
What a frustrating beauty
to know I could never
so accurately place the
clock
of their heartbeat
into art.

If earth is mother
I am the son
who grew into more than one.

I cautiously come
worshipping fun
observing heaviest light, leveling height.

Did I look done?

Maybe some thought
my love was lost
when I walked in the darkness
convincingly not.

But my faith doesn't like
only the light
and held the love true,
if nothing else knew.

Why be afraid
and alone with my thoughts?
Why be tame
and feign action?

Love you knew and know
blesses inside and outside,
forever you grow.

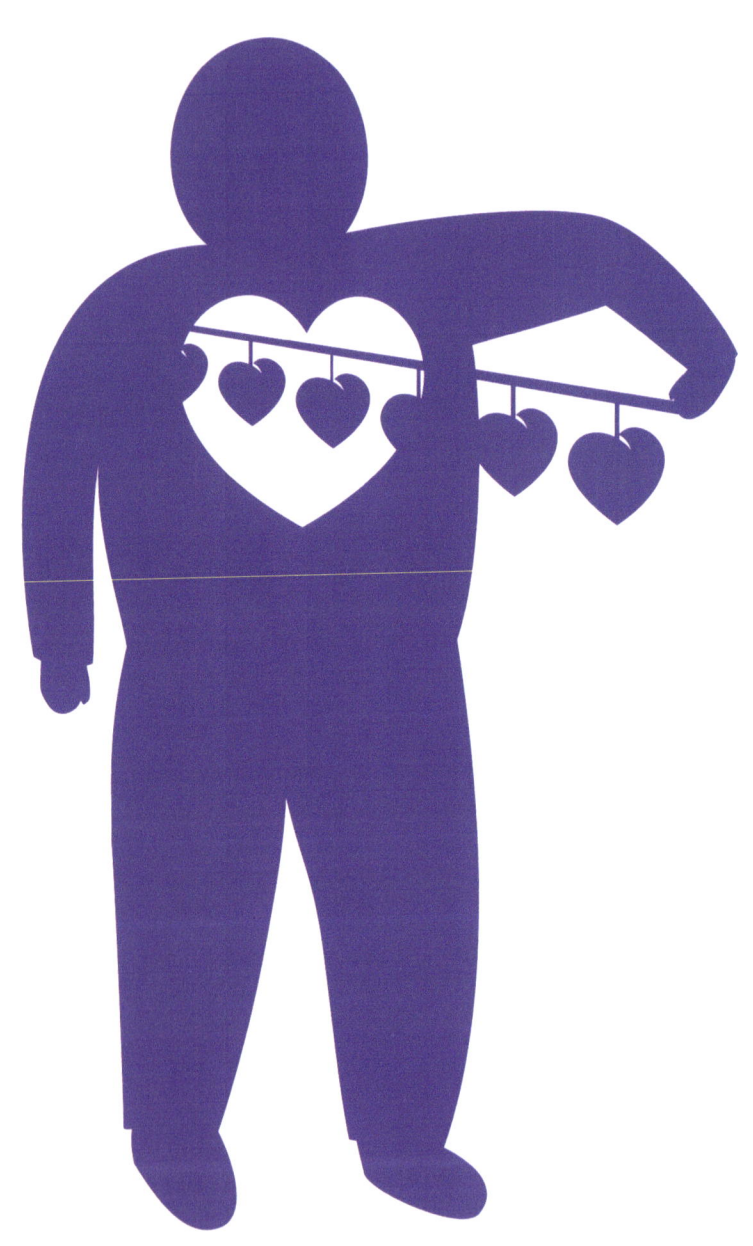

www.ingramcontent.com/pod-product-compliance
Lightning Source LLC
Chambersburg PA
CBHW051107180526
45172CB00002B/802